T0315292

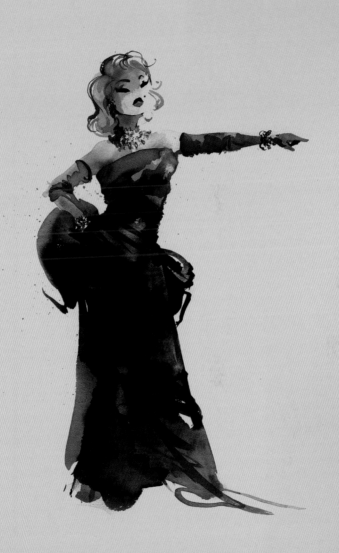

ICONS OF STYLE

MARILYN MONROE

Harper *by* Design

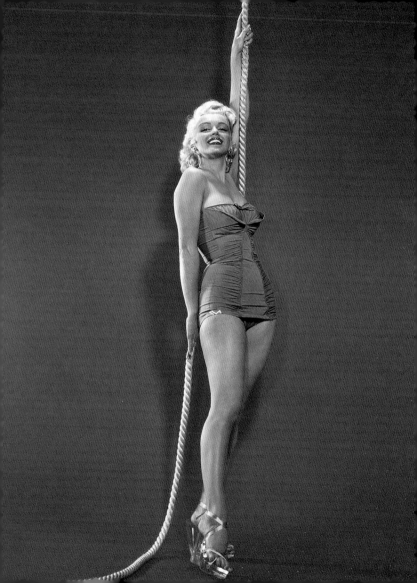

I AM NOT INTERESTED IN MONEY. I JUST WANT TO BE WONDERFUL.

I LEARNED
TO WALK AS A
BABY AND
I HAVEN'T HAD
A LESSON SINCE.

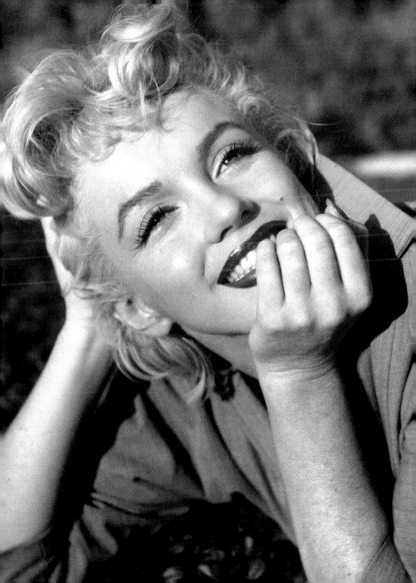

SHE WAS BEAUTIFUL AND UNTOUCHED; IT WAS AS THOUGH SHE WERE JUST BEGINNING.

Bert Stern

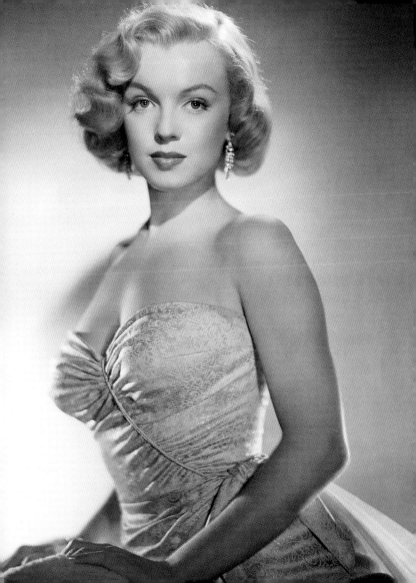

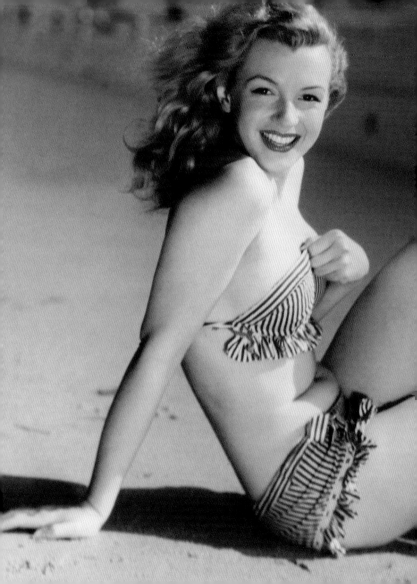

FIRST, I'M TRYING TO PROVE TO MYSELF THAT I'M A PERSON. THEN MAYBE I'LL CONVINCE MYSELF THAT I'M AN ACTRESS.

EVERYONE ELSE IS EARTHBOUND BY COMPARISON.

Billy Wilder

I'M GOING TO BE A GREAT MOVIE STAR SOME DAY.

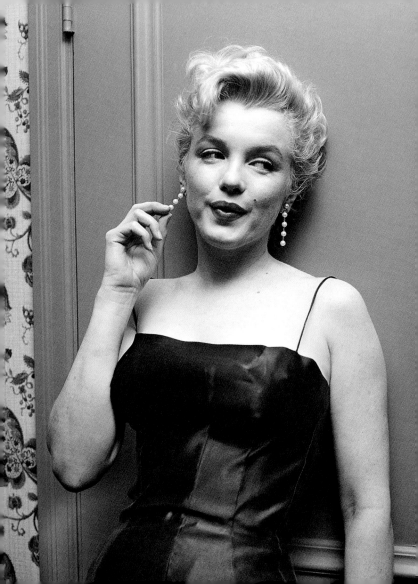

I'M A
MIXTURE OF
SIMPLICITY AND
COMPLEXES.

FRANKLY, I'VE NEVER CONSIDERED MY OWN FIGURE SO EXCEPTIONAL.

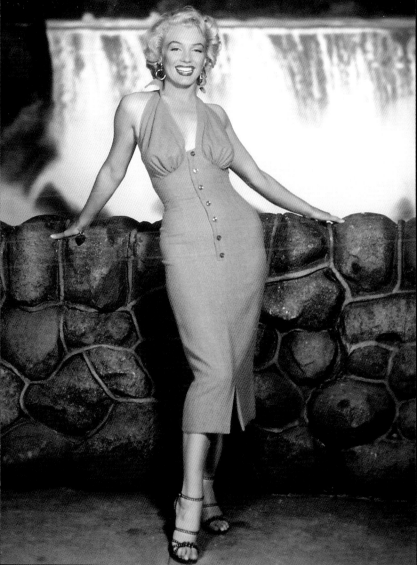

A WOMAN LOOKS AT YOUR CLOTHES CRITICALLY. A MAN APPRECIATES THEM.

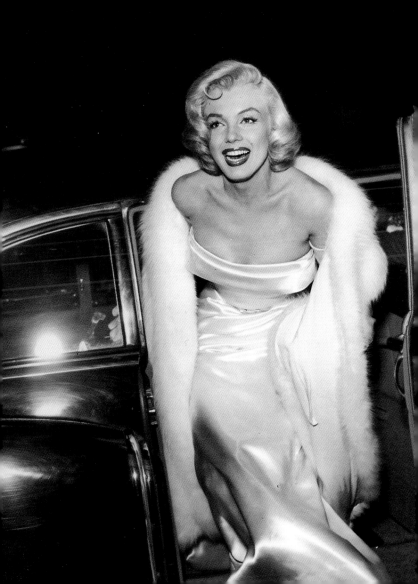

I DON'T MIND
LIVING IN A MAN'S
WORLD AS LONG
AS I CAN BE A
WOMAN IN IT.

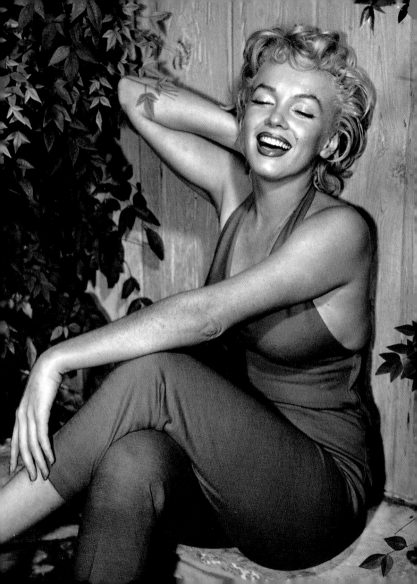

MOST IMPORTANTLY, KEEP SMILING.

THERE ISN'T ANYBODY THAT LOOKS LIKE ME WITHOUT CLOTHES ON.

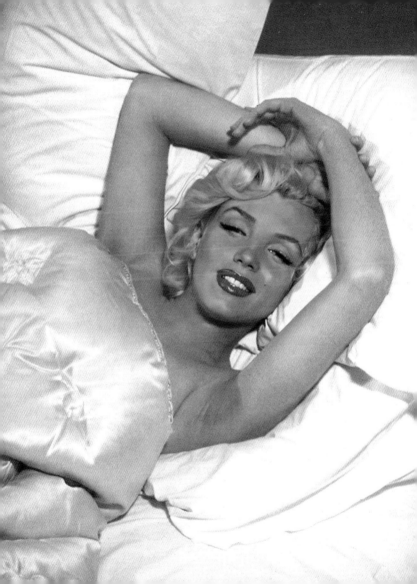

I WANT TO DO THE BEST THAT I CAN DO IN THAT MOMENT, WHEN THE CAMERA STARTS, UNTIL IT STOPS.

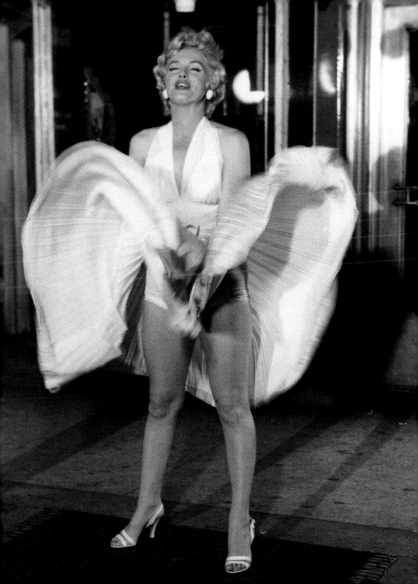

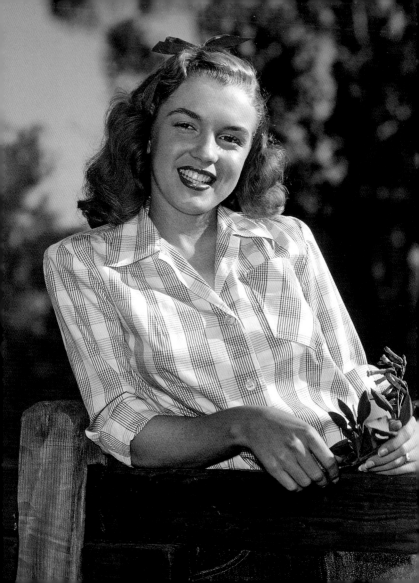

ALL LITTLE GIRLS SHOULD BE TOLD THEY ARE PRETTY, EVEN IF THEY AREN'T.

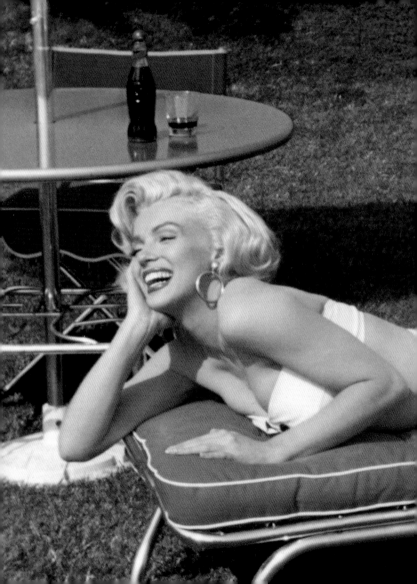

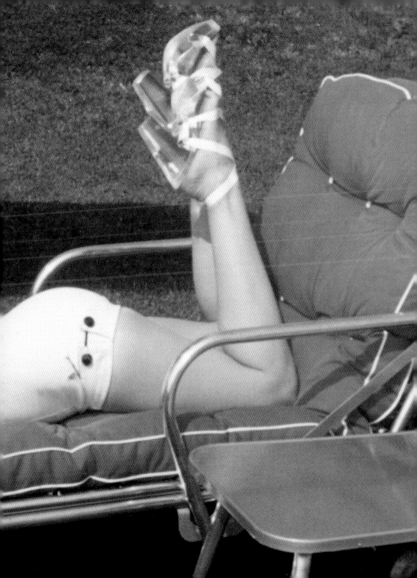

I DON'T MIND BEING
BURDENED WITH
BEING GLAMOROUS
AND SEXUAL. BUT
WHAT GOES WITH IT
CAN BE A BURDEN.

MARILYN IS
NOT ANY ONE
THING; SHE'S
MULTIDIMENSIONAL.

Eli Wallach

IT'S NICE TO BE INCLUDED IN PEOPLE'S FANTASIES BUT YOU ALSO LIKE TO BE ACCEPTED FOR YOUR OWN SAKE.

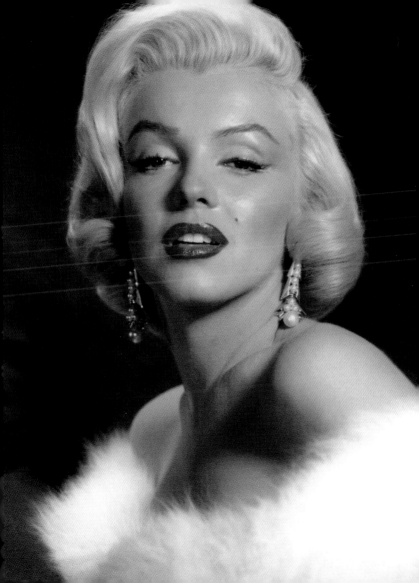

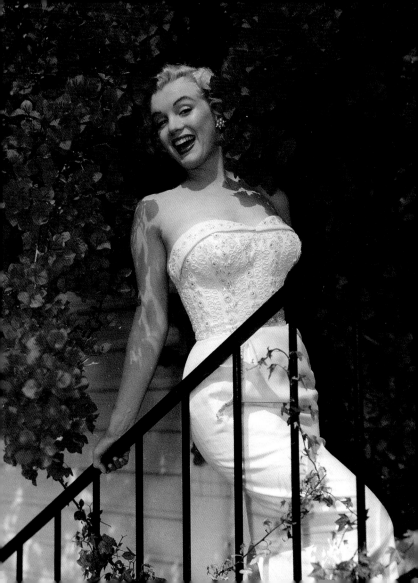

IT'S A MAKE-BELIEVE WORLD, ISN'T IT?

SEX IS PART OF NATURE. I GO ALONG WITH NATURE.

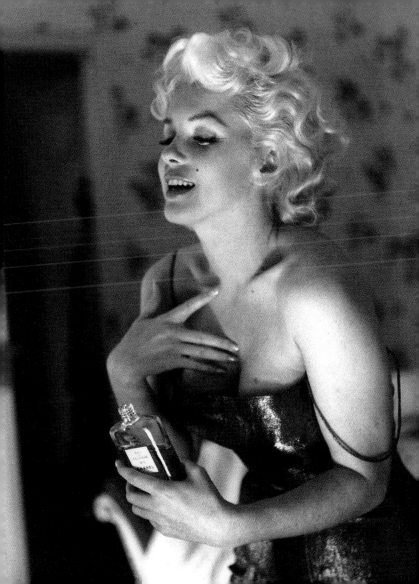

THERE WAS
MY NAME UP IN
LIGHTS. I SAID,
'GOD, SOMEBODY'S
MADE A MISTAKE.'

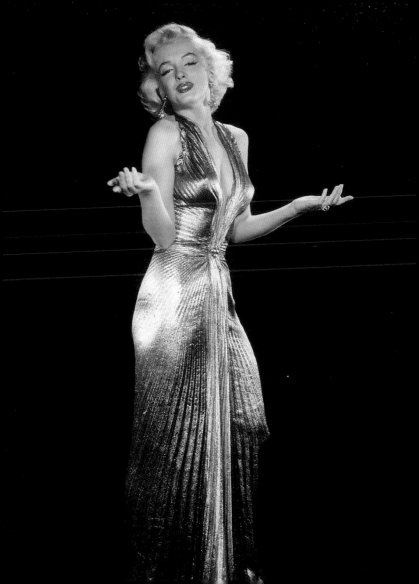

ONLY THE PUBLIC
CAN MAKE A STAR.
IT'S THE STUDIOS
WHO TRY TO MAKE
A SYSTEM OUT OF IT.

SHE HAD A GREAT NATURAL DIGNITY AND WAS EXTREMELY INTELLIGENT.

Edith Sitwell

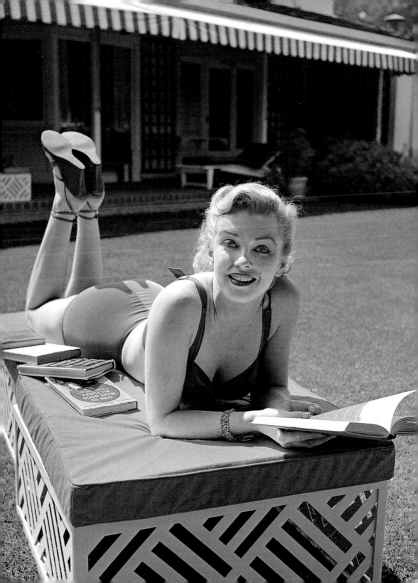

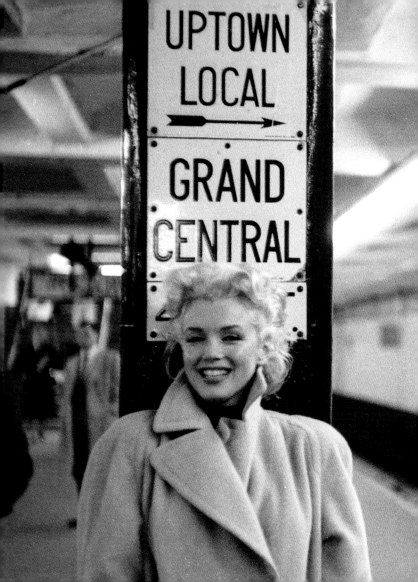

UPTOWN
LOCAL
→

GRAND
CENTRAL

WHAT DO I WEAR
IN BED? WHY,
CHANEL Nº 5,
OF COURSE.

MARILYN IS A KIND
OF ULTIMATE.
SHE IS UNIQUELY
FEMININE.

Clark Gable

WHO SAID NIGHTS WERE FOR SLEEP?

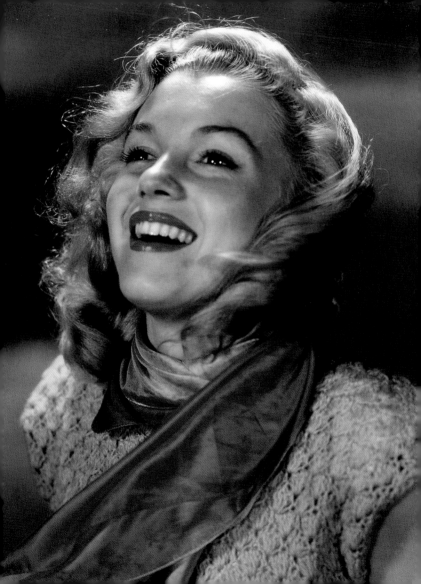

HER BEAUTY AND
HUMANITY SHINE
THROUGH ... SHE
CREATED SOMETHING
EXTRAORDINARY.

Arthur Miller

ALL WE DEMANDED WAS OUR RIGHT TO TWINKLE.

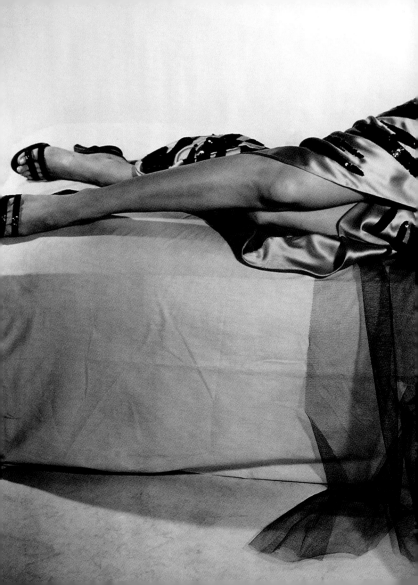

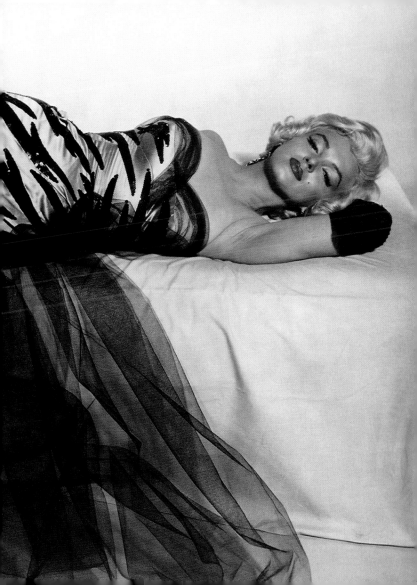

WE SHOULD ALL
START TO LIVE
BEFORE WE GET
TOO OLD.

MARILYN IS AS NEAR A GENIUS AS ANY ACTRESS I EVER KNEW.

Joshua Logan

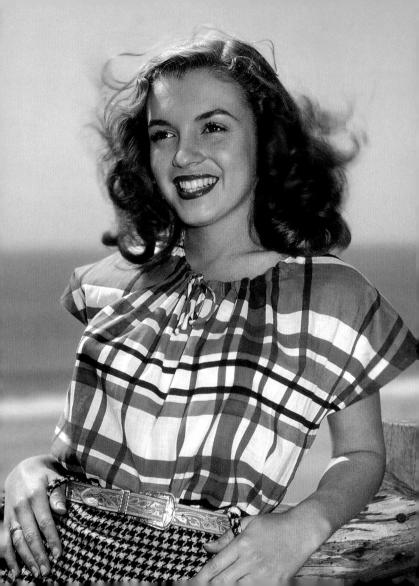

I NEVER WANTED
TO BE MARILYN –
IT JUST HAPPENED.
MARILYN'S LIKE A
VEIL I WEAR OVER
NORMA JEANE.

I AM VERY DEFINITELY A WOMAN AND I ENJOY IT.

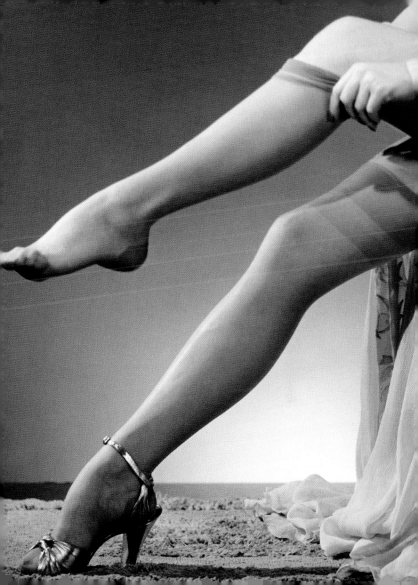

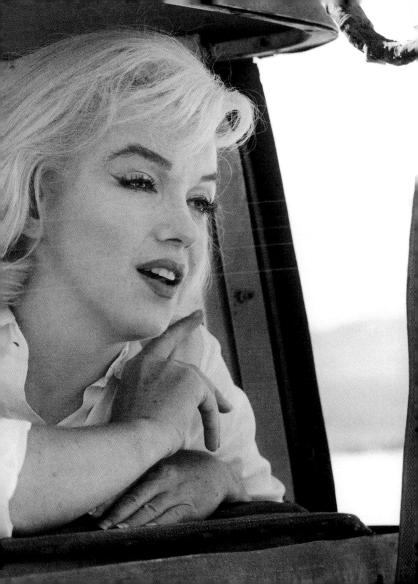

A WOMAN KNOWS
BY INTUITION,
OR INSTINCT,
WHAT IS BEST
FOR HERSELF.

I DON'T LOOK
AT MYSELF AS A
COMMODITY, BUT
I'M SURE A LOT OF
PEOPLE HAVE.

[HOLLYWOOD IS]
A PLACE WHERE
THEY'LL PAY YOU
A THOUSAND
DOLLARS FOR A KISS
AND FIFTY CENTS
FOR YOUR SOUL.

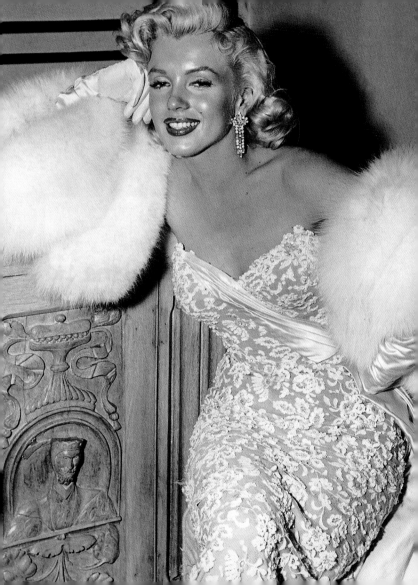

FAME IS FICKLE AND I KNOW IT.

SHE MANAGED ALL THE BUSINESS OF STARDOM WITH UNCANNY, CLEVER, APPARENT EASE.

Laurence Olivier

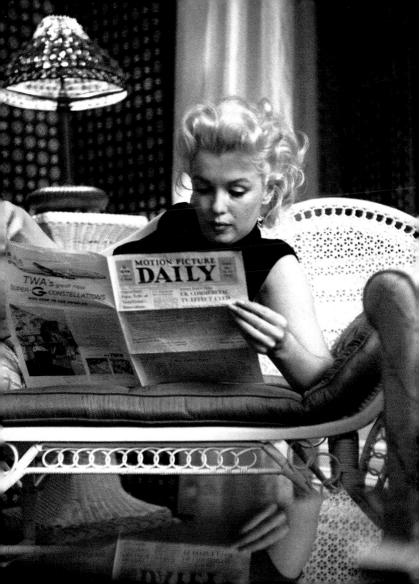

FEAR IS STUPID.
SO ARE
REGRETS.

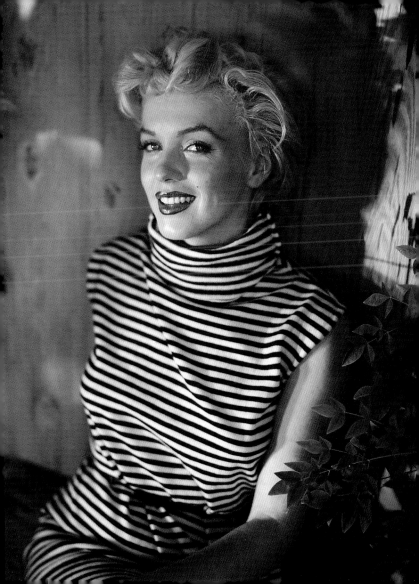

SEXUALITY IS ONLY ATTRACTIVE WHEN IT'S NATURAL AND SPONTANEOUS.

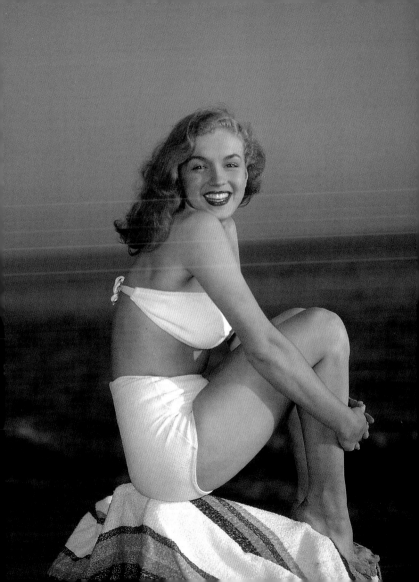

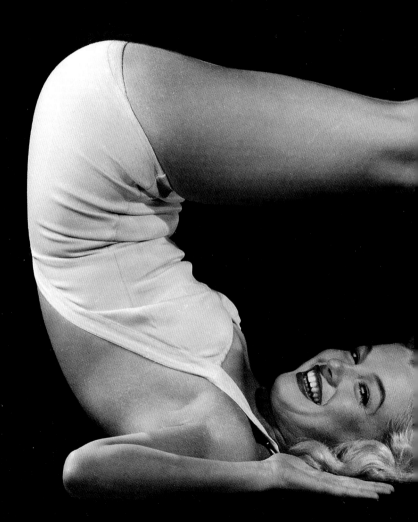

I WANT TO GROW OLD WITHOUT FACELIFTS.

I DON'T MIND MAKING JOKES, BUT I DON'T WANT TO LOOK LIKE ONE.

SHE HAS A CERTAIN INDEFINABLE MAGIC ... WHICH NO OTHER ACTRESS IN THE BUSINESS HAS.

Billy Wilder

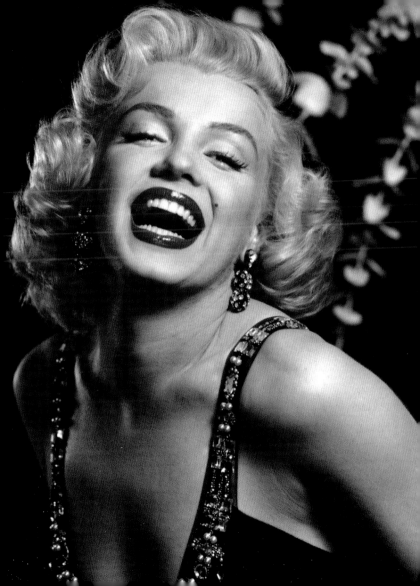

EVERYBODY IS
ALWAYS TUGGING
AT YOU. THEY'D
ALL LIKE A SORT
OF CHUNK OUT
OF YOU.

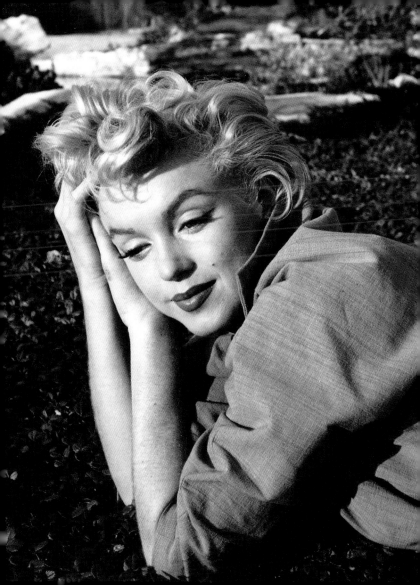

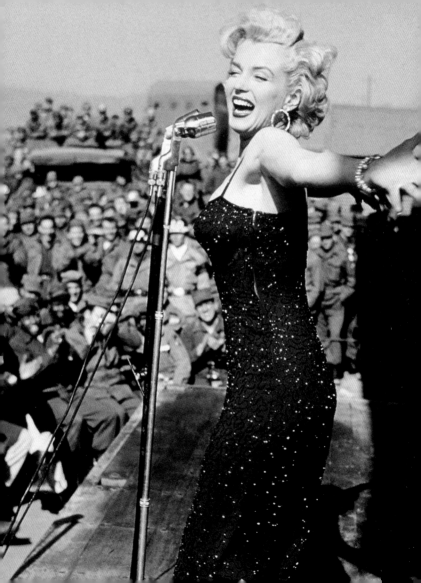

IF I AM A STAR, THE PEOPLE MADE ME A STAR.

I'VE SPENT MOST OF MY LIFE RUNNING AWAY FROM MYSELF.

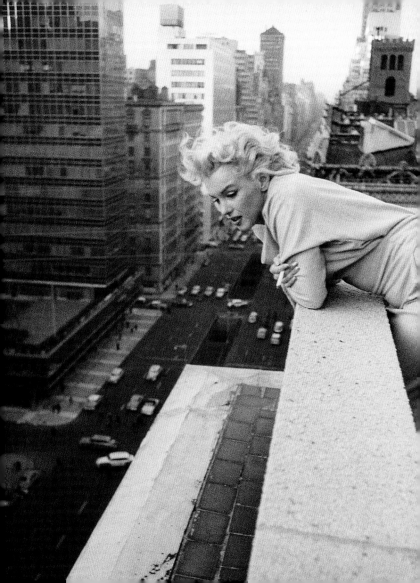

MARILYN PLAYED
THE BEST GAME
WITH THE WORST
HAND OF ANYBODY
I KNOW.

Edward Wagenknecht

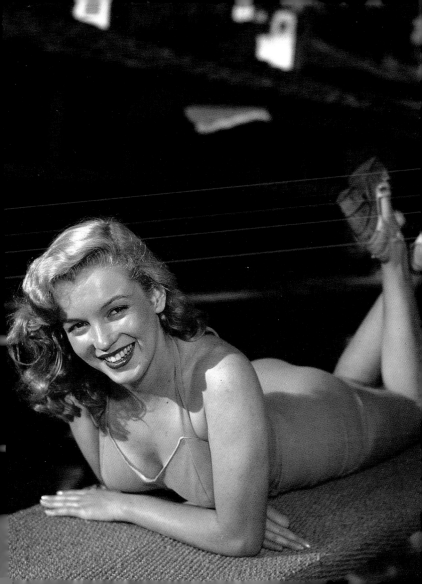

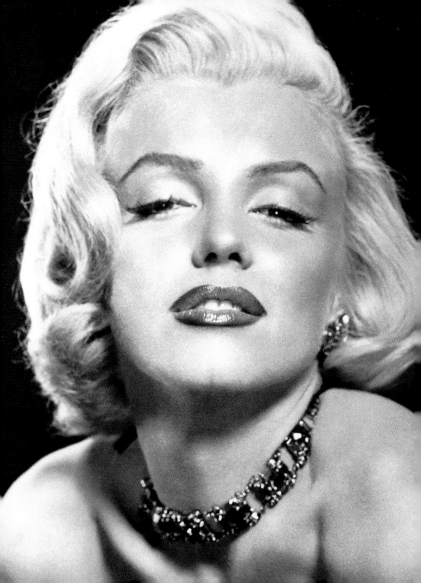

I WANT TO HAVE
THE COURAGE
TO BE LOYAL
TO THE FACE
I HAVE MADE.

Harper *by* Design

An imprint of HarperCollins*Publishers*

HarperCollins*Publishers*
Australia • Brazil • Canada • France • Germany • Holland • India
Italy • Japan • Mexico • New Zealand • Poland • Spain • Sweden
Switzerland • United Kingdom • United States of America

HarperCollins acknowledges the Traditional Custodians of the land upon which we live and work,
and pays respect to Elders past and present.

First published in Australia in 2023
by HarperCollins*Publishers* Australia Pty Limited
Gadigal Country
Level 13, 201 Elizabeth Street, Sydney NSW 2000
ABN 36 009 913 517
harpercollins.com.au

Design and compilation copyright © HarperCollins*Publishers* Australia Pty Limited 2023

A catalogue record for this book is available from the National Library of Australia

ISBN 978 1 4607 6384 1

Publisher: Mark Campbell
Publishing Director: Brigitta Doyle
Project Editor: Barbara McClenahan
Designer: Mietta Yans, HarperCollins Design Studio
Illustrator: Gypsy Taylor
Photography by Alamy Stock Photo: 47; ARCHIVIO GBB / Alamy Stock Photo: 27; Baron via Getty Images: 7, 24, 77,
87; Bettmann via Getty Images: 9, 29, 88, 94; Darlene Hammond via Getty Images: 72; Donaldson Collection via Getty
Images: 30, 62, 79; Ernst Haas via Getty Images: 66–7; iStock: 14, 44, 53, 65, 71; John Kobal Foundation via Getty
Images: 80–1; M. Garrett via Getty Images: 21; Michael Ochs Archives via Getty Images: 4, 16, 32–33, 38, 41, 48–9,
58–9, 75, 85, 91, 93; Shutterstock: back cover, title page, 22, 57; Sunset Boulevard via Getty Images: 10–11, 19, 37, 43, 54
Colour reproduction by Splitting Image Colour Studio, Wantirna VIC
Printed and bound in China by 1010 Printing

8 7 6 5 4 3 2 1 23 24 25 26